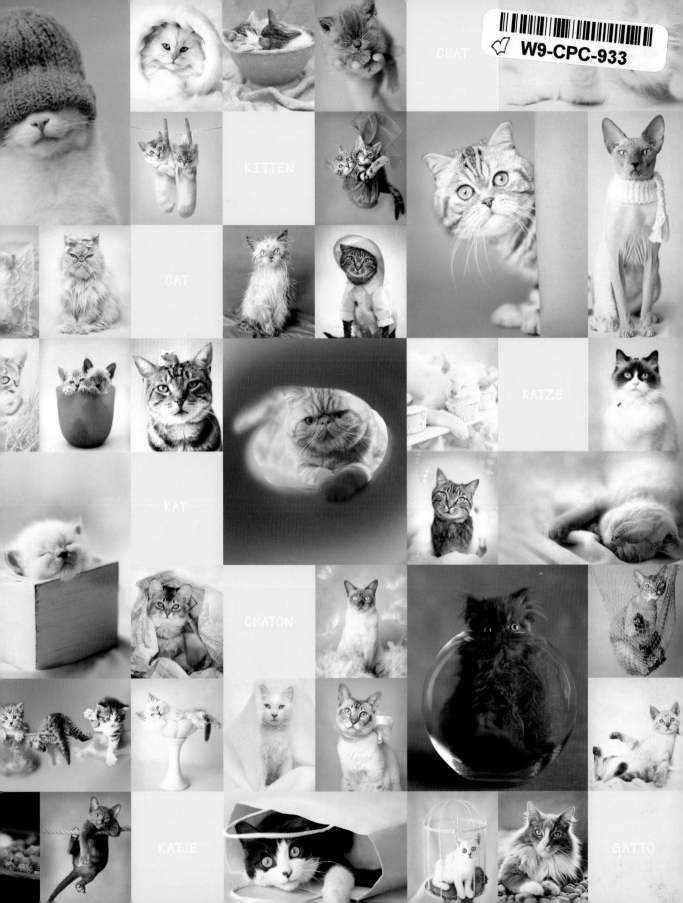

THIS BOOK BELONGS TO:

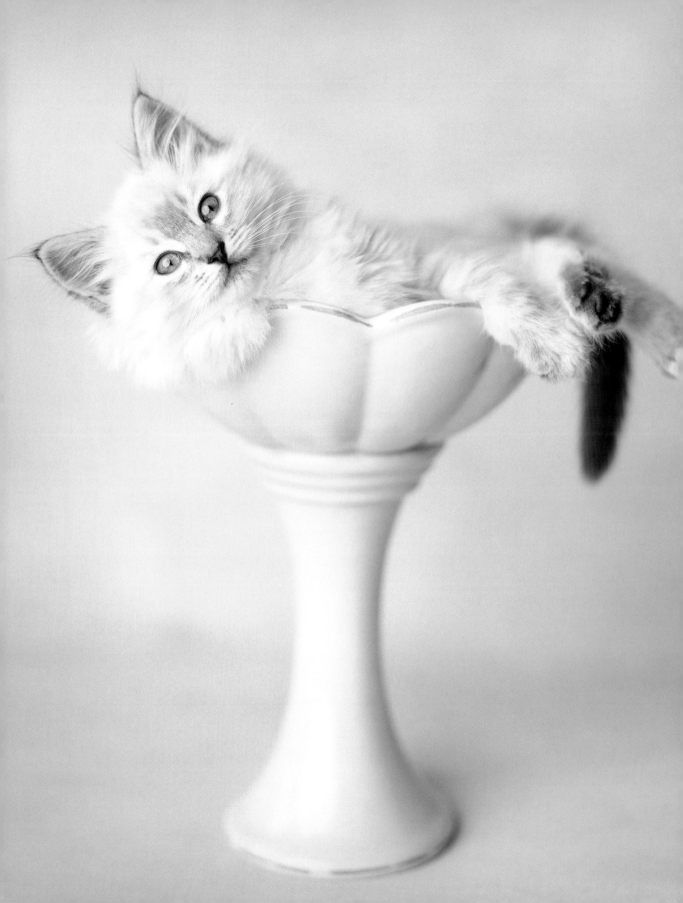

MY CAT RECORD BOOK

RACHAEL HALE

Bulfinch Press
New York • Boston

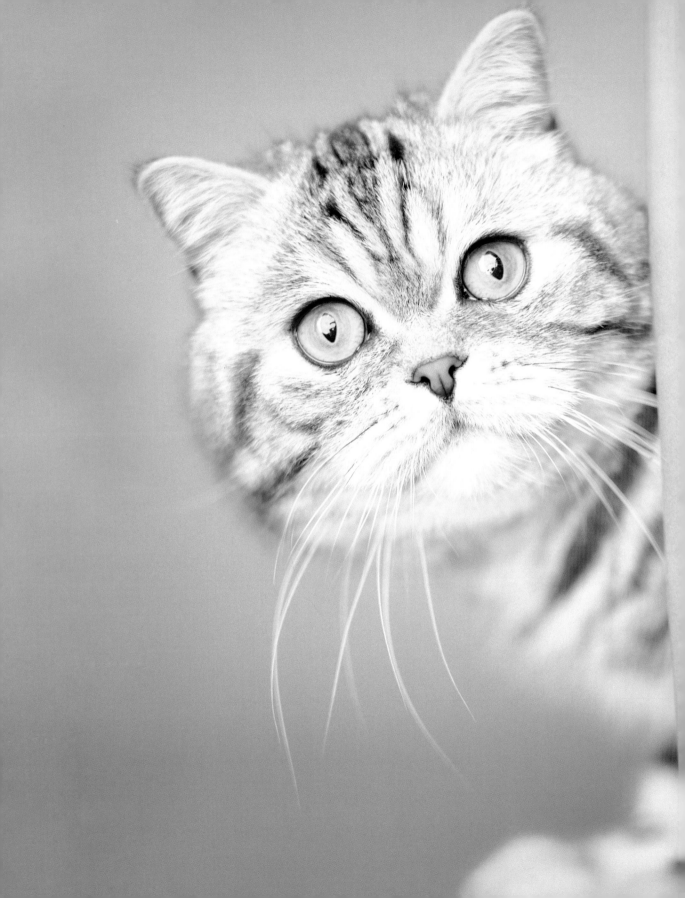

CONTENTS

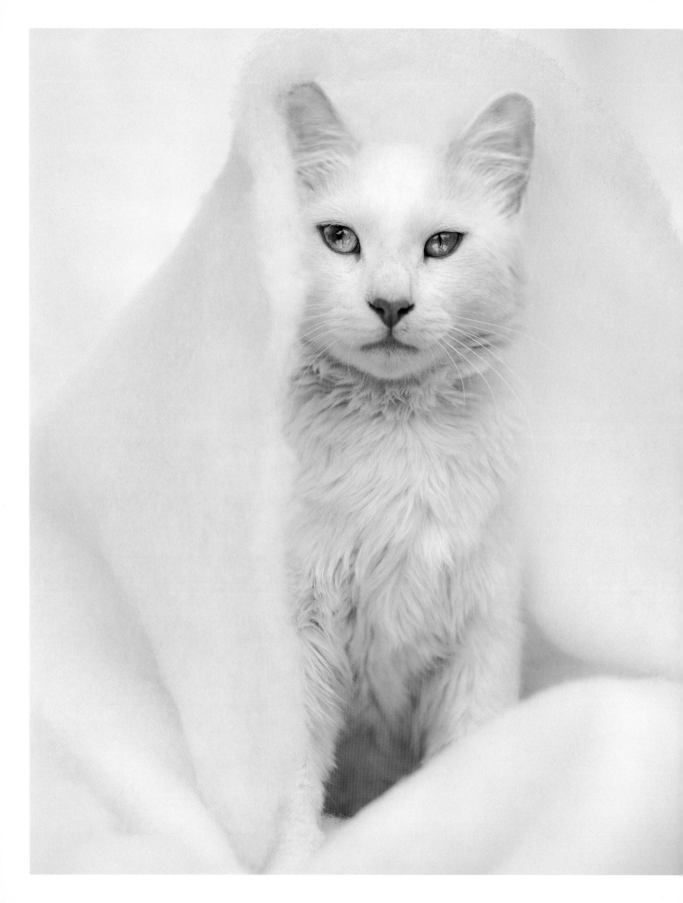

COLLAR

IDENTITY TAG

FOOD BOWL

WATER BOWL

TOYS

SUITABLE KITTEN FOOD

LITTER BOX

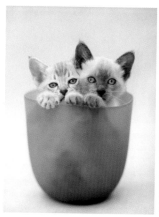
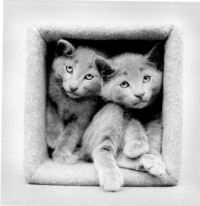
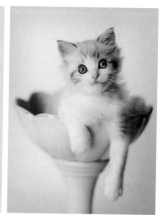

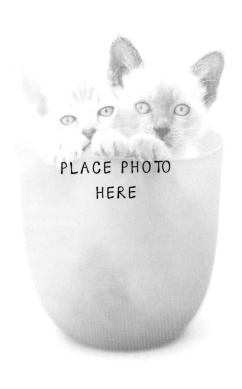

PLACE PHOTO
HERE

I was born on

There were kittens in my litter

Date I came home

Address of family home

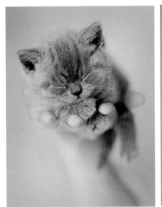 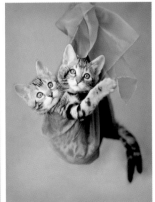

CHOOSING MY NAME

Names that were considered

Inspiration for my name

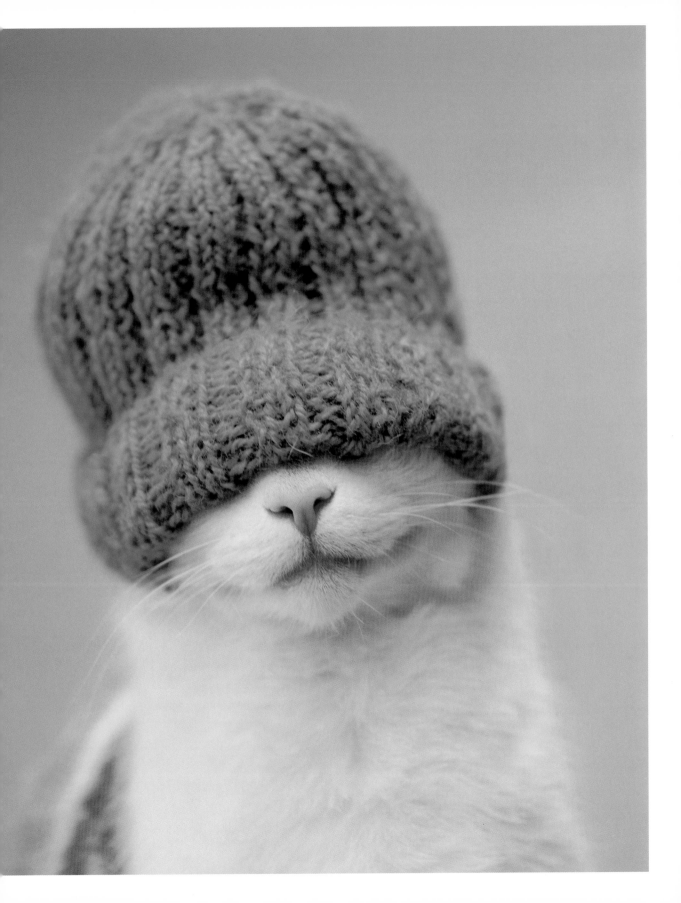

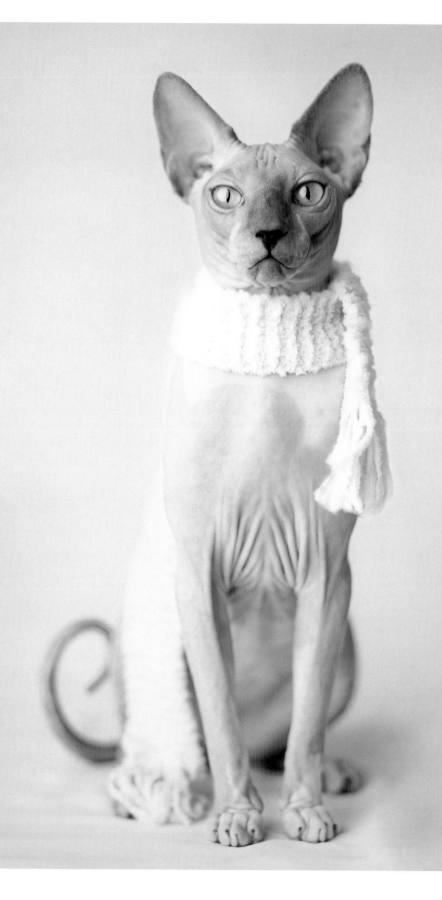

MY BREED

I am a

We are known for

BEST FEATURES

My eyes are

My paws are

My ears are

My whiskers are

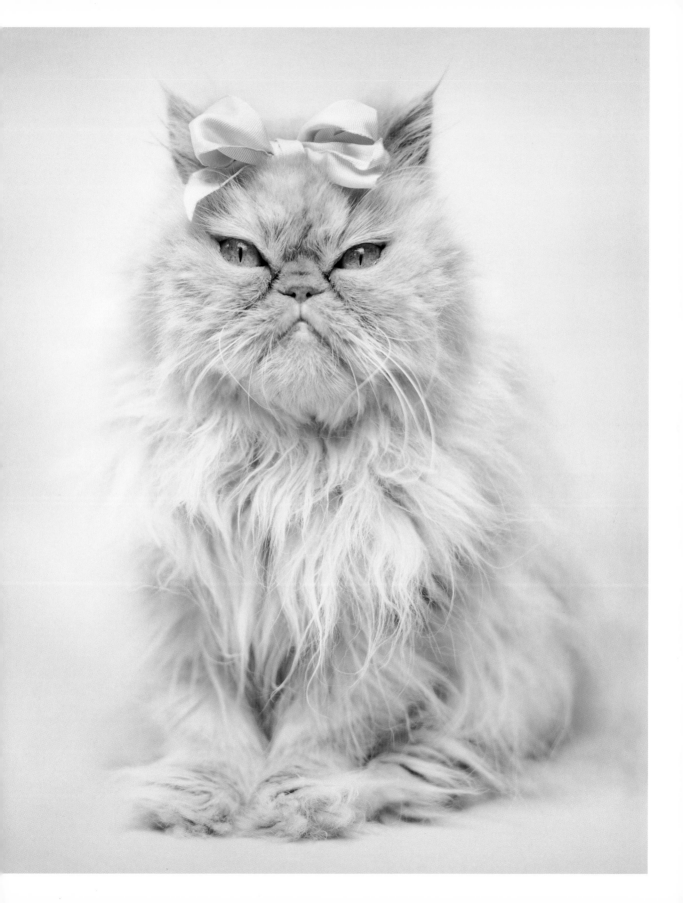

GRANDFATHER

Birthplace

Date

FATHER

Birthplace

Date

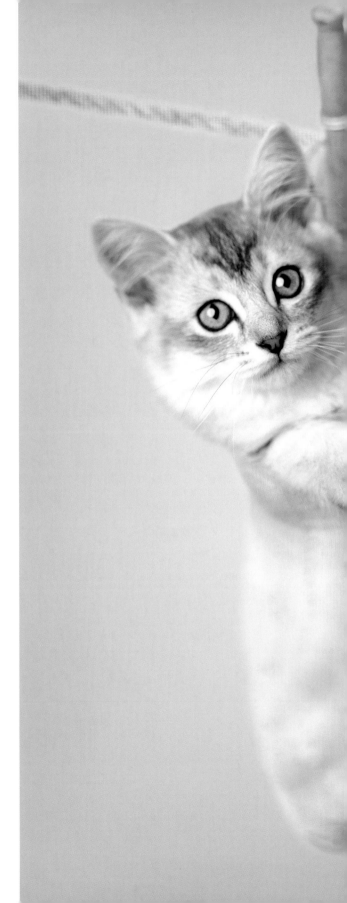

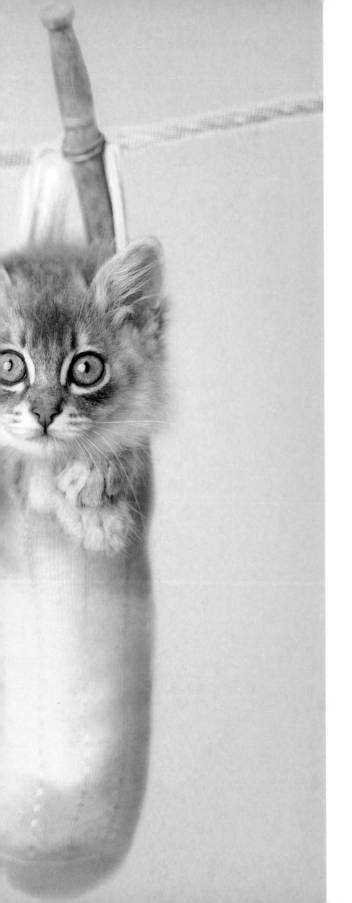

FAMILY TREE

GRANDMOTHER

Birthplace

Date

MOTHER

Birthplace

Date

PLACE PHOTO
HERE

MY FAMILY

My owner is

We live at

Family members

Other pets

Other relatives

Neighbors

GROWING UP

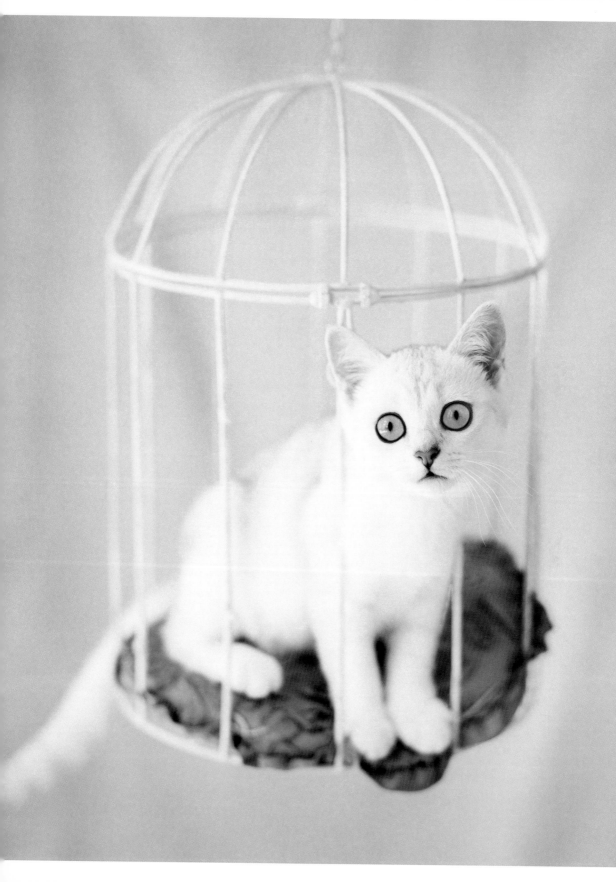

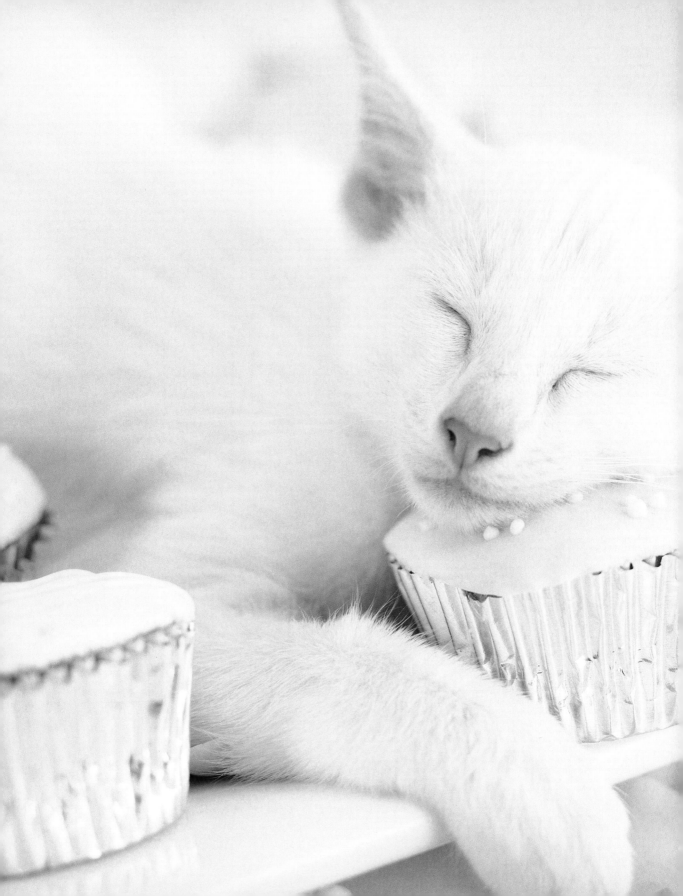

SPECIAL MOMENTS

BIRTHDAYS

Year

Gifts

Party guests

Year

Gifts

Party guests

Year

Gifts

Party guests

Year

Gifts

Party guests

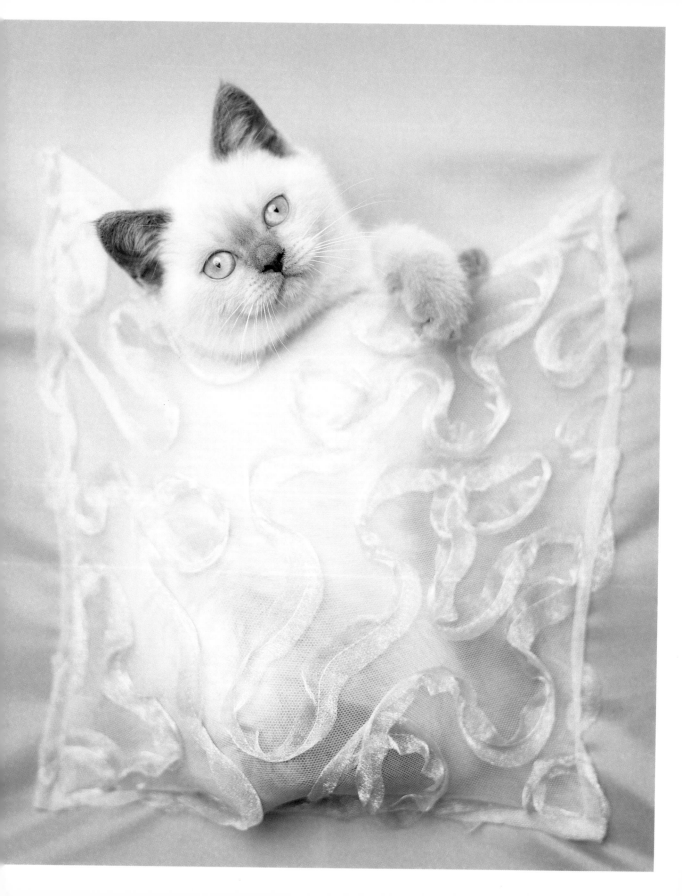

PLACE PHOTO
HERE

BIRTHDAYS

Year

Gifts

Party guests

Year

Gifts

Party guests

Year

Gifts

Party guests

Year

Gifts

Party guests

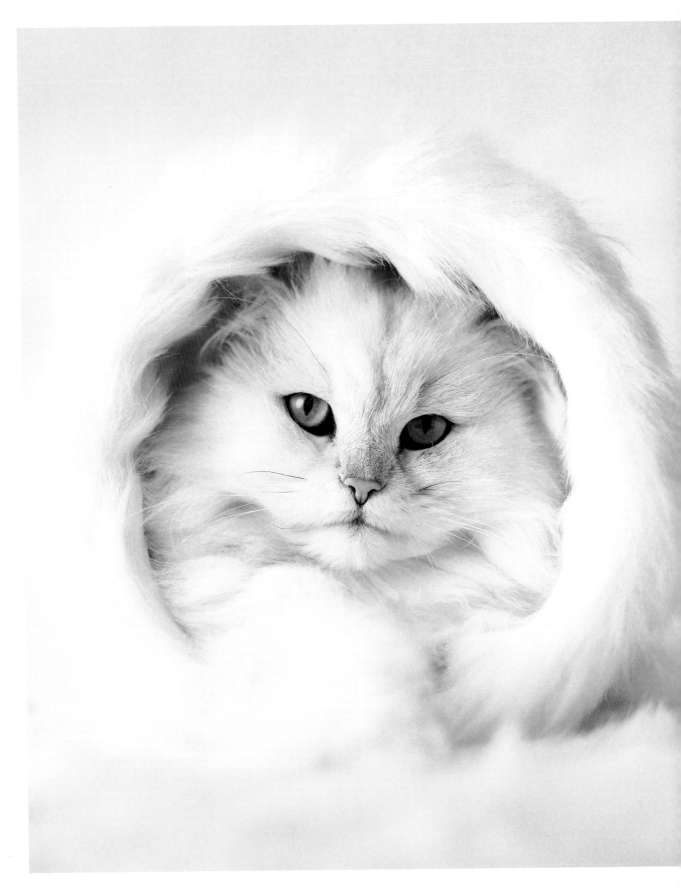

MY FAVORITE TOYS

OUTINGS

BEST FRIENDS

MY FAVORITE PASTIMES

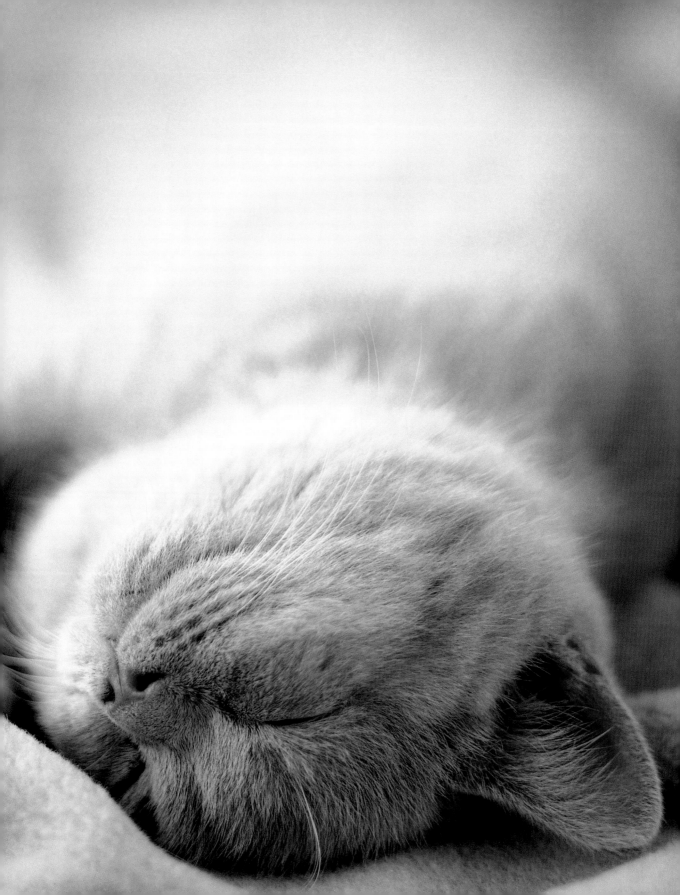

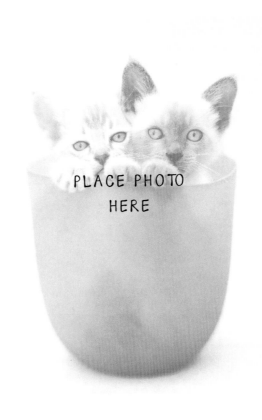

PLACE PHOTO
HERE

MY FAVORITE PASTIMES

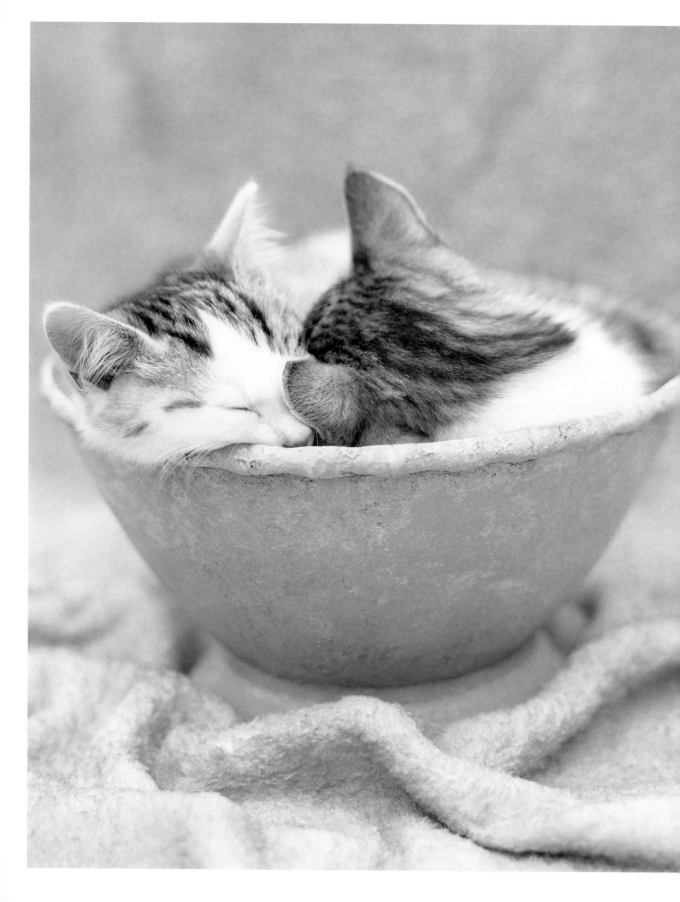

MY FAVORITE PLACES TO SLEEP

VACATIONS

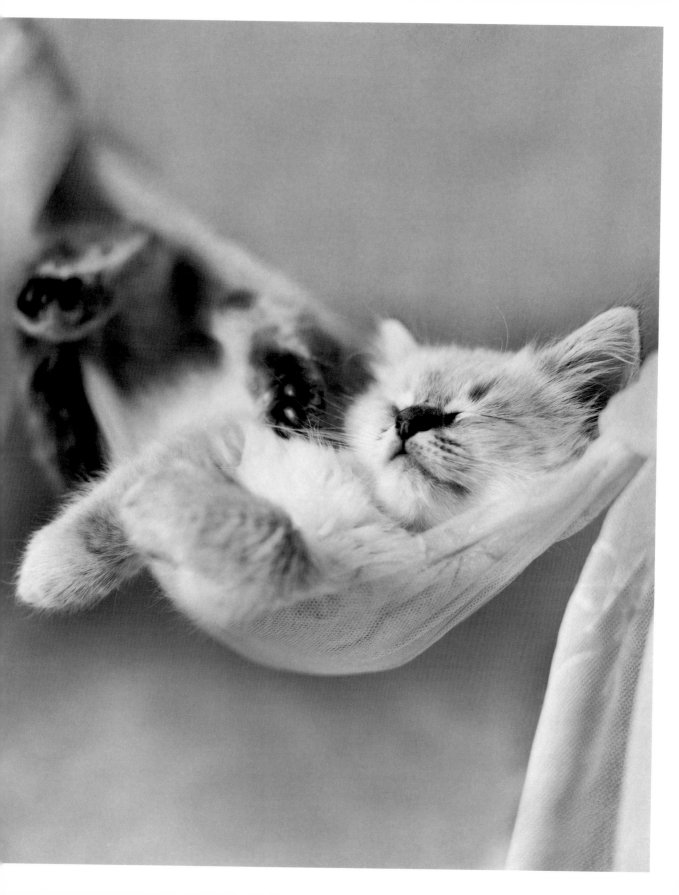

ADVENTURES

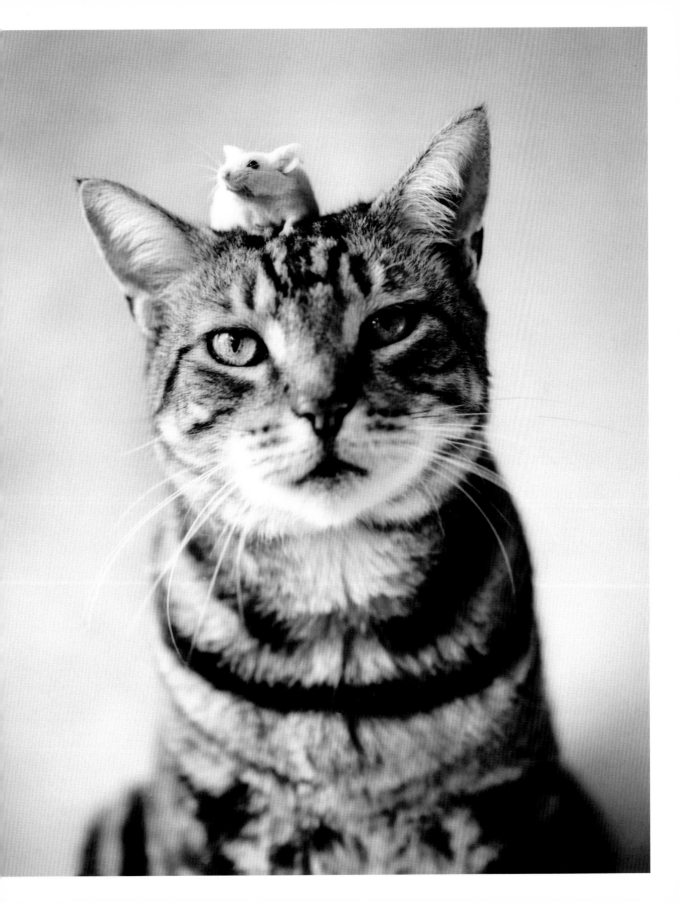

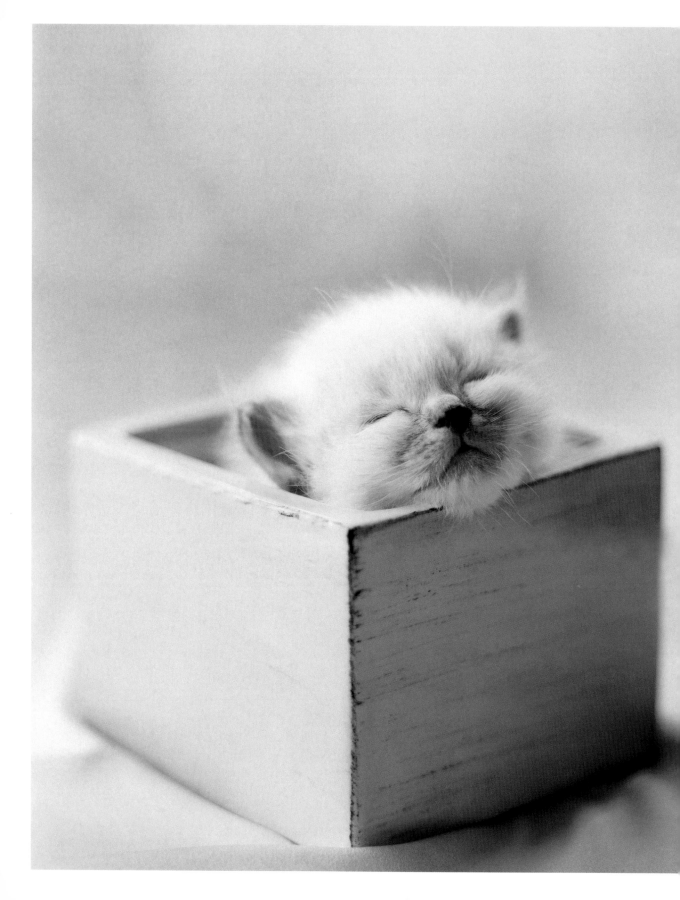

ACHIEVEMENTS

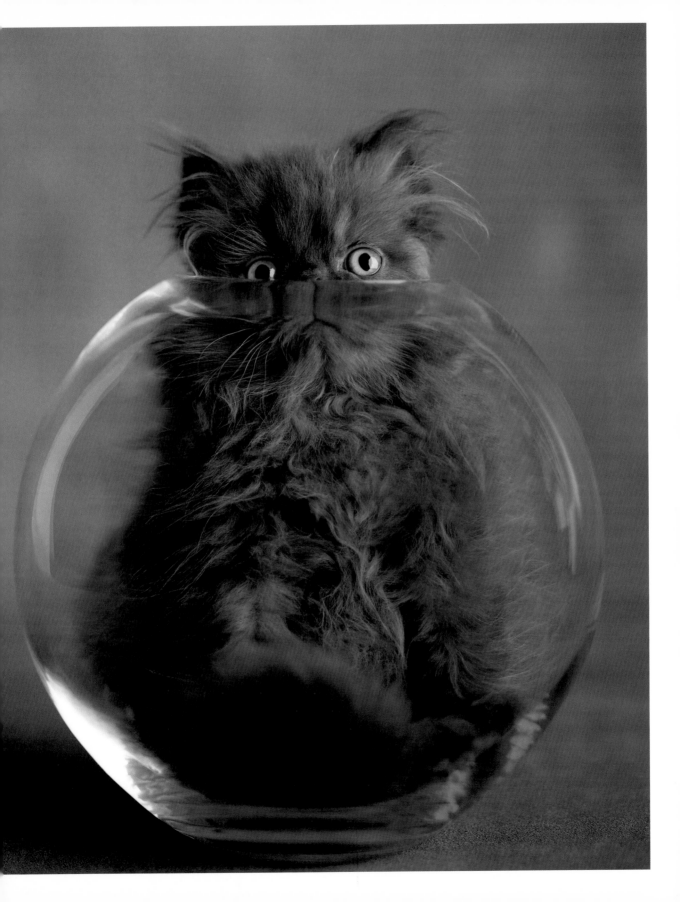

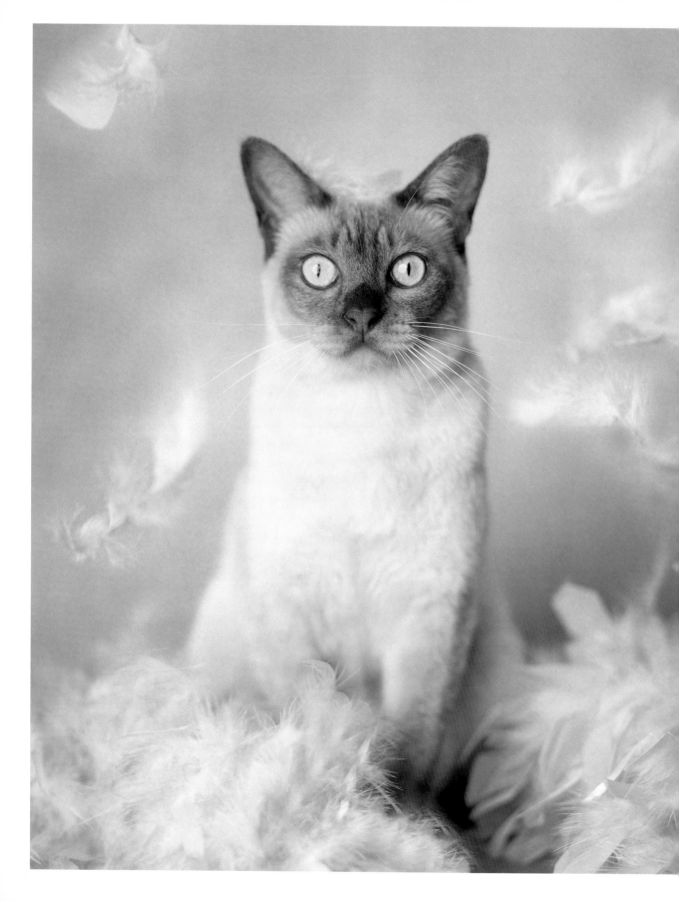

ANNOYING HABITS

PLACE PHOTO HERE

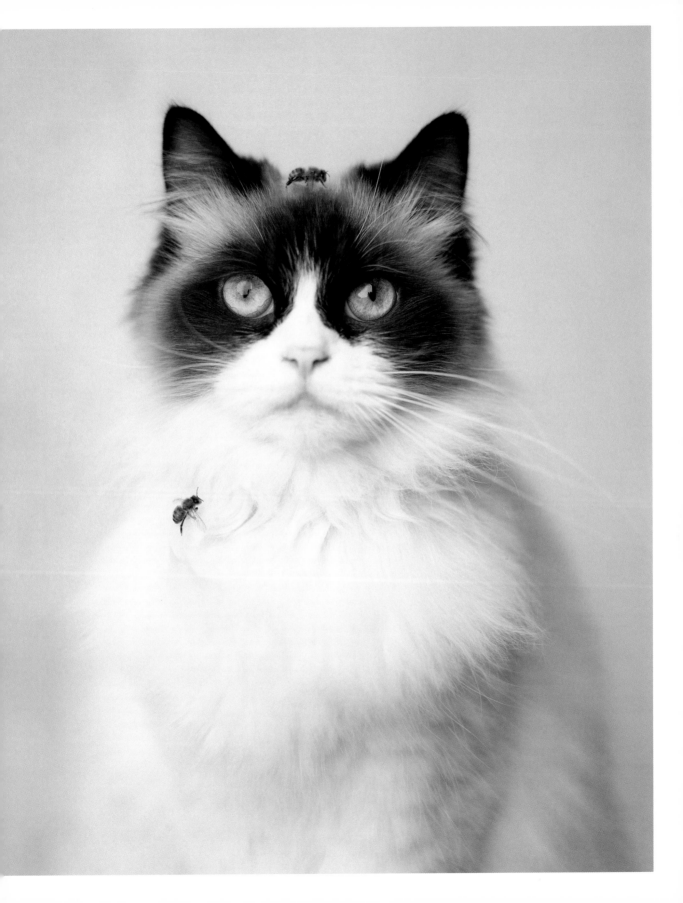

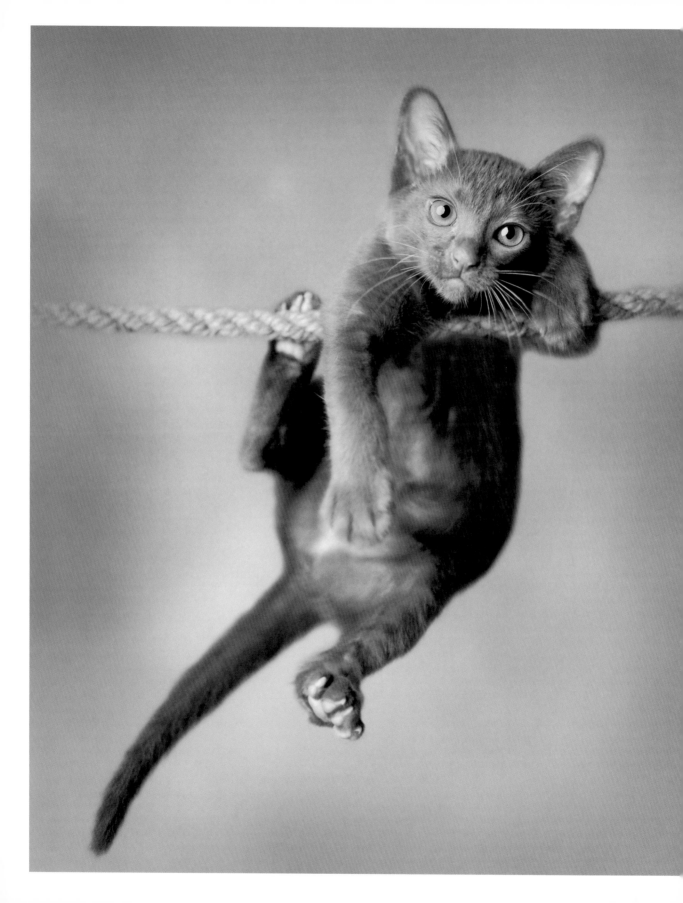

GROOMING

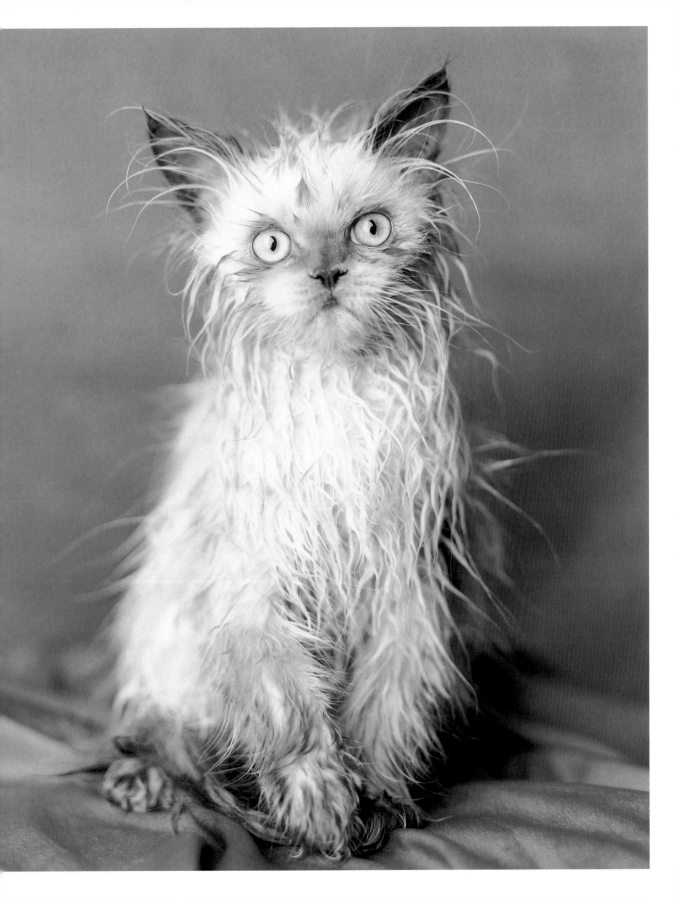

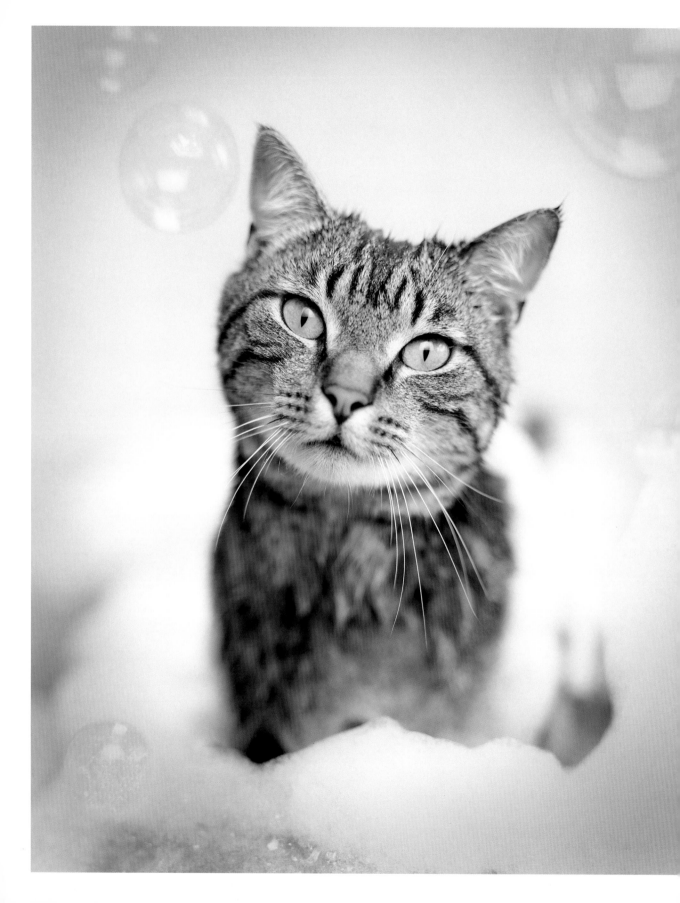

PLACE PHOTO
HERE

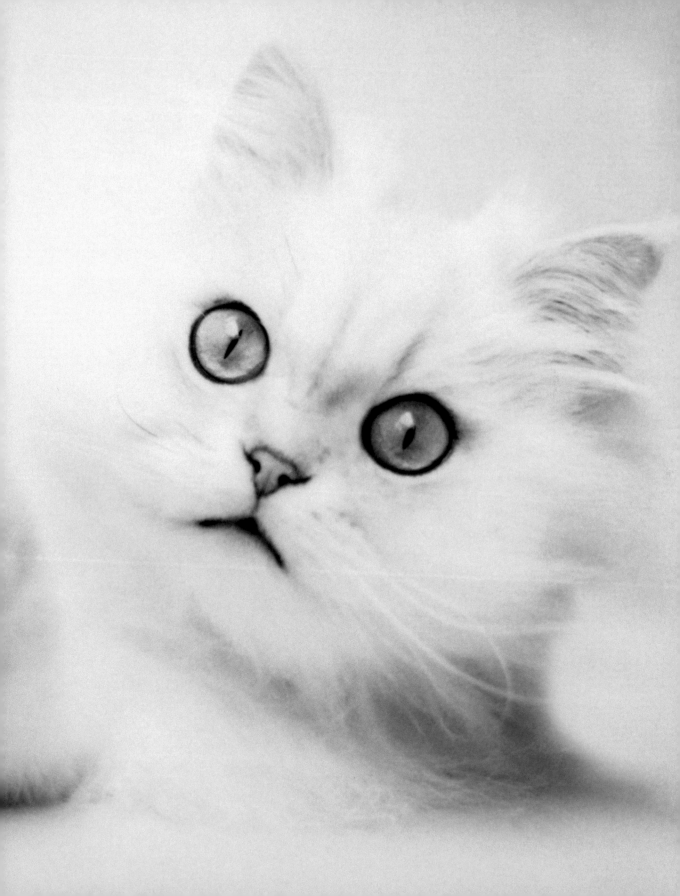

PAW PRINTS

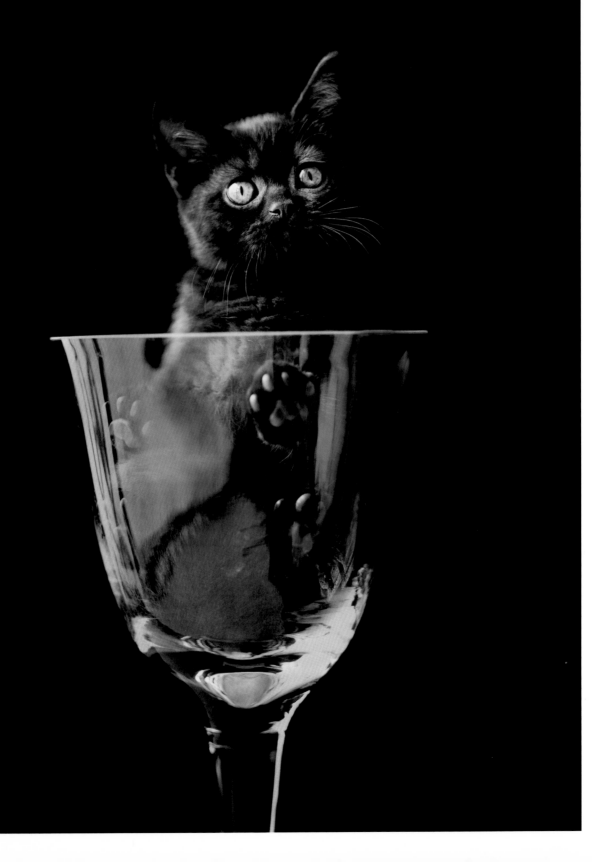

TRAINING

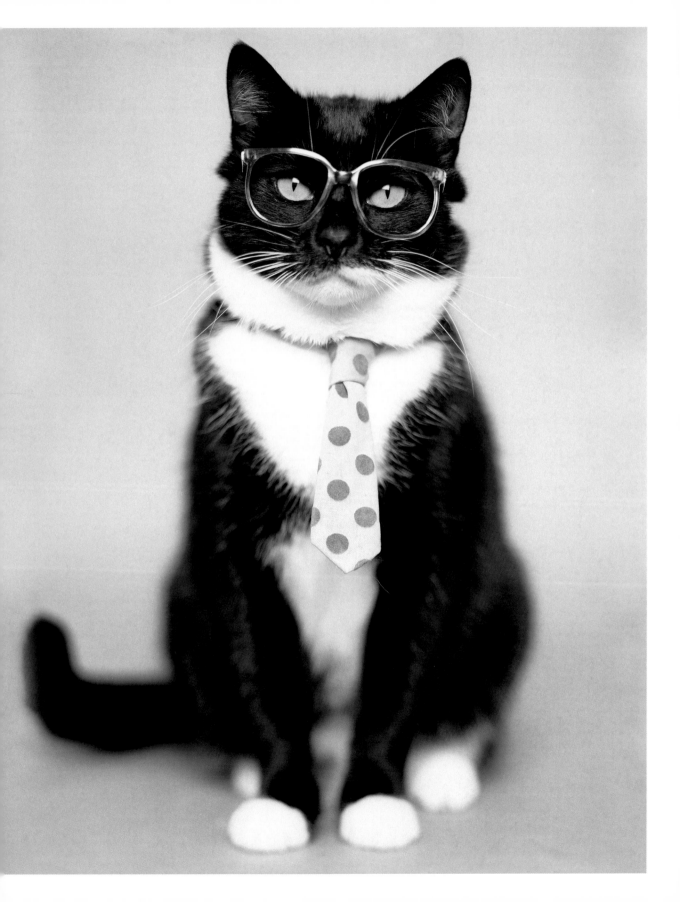

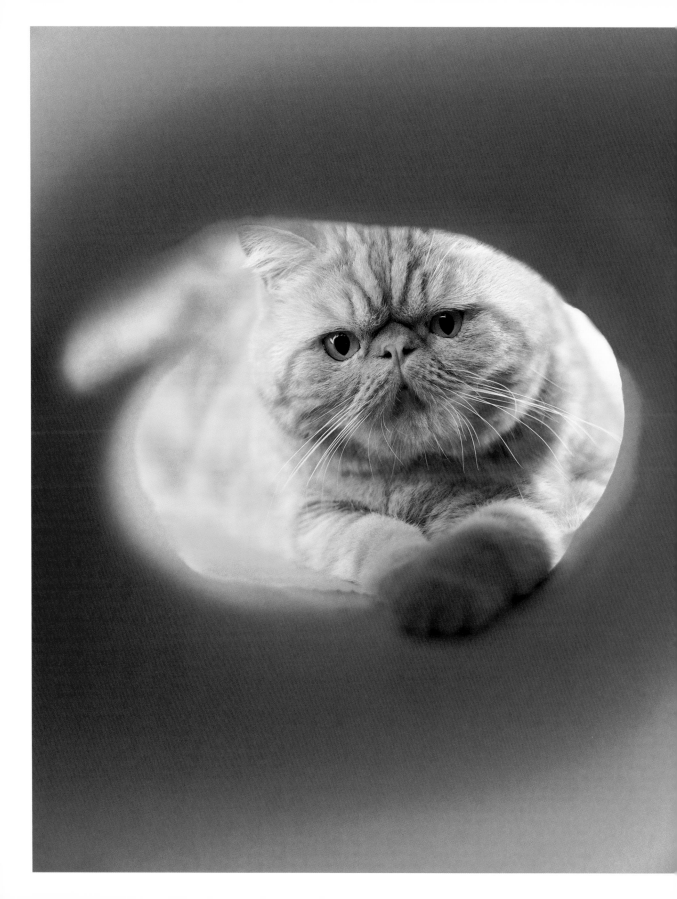

Age/Length/Weight

Date	Age	Length	Weight

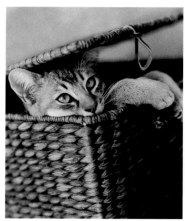
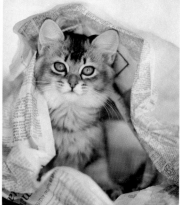

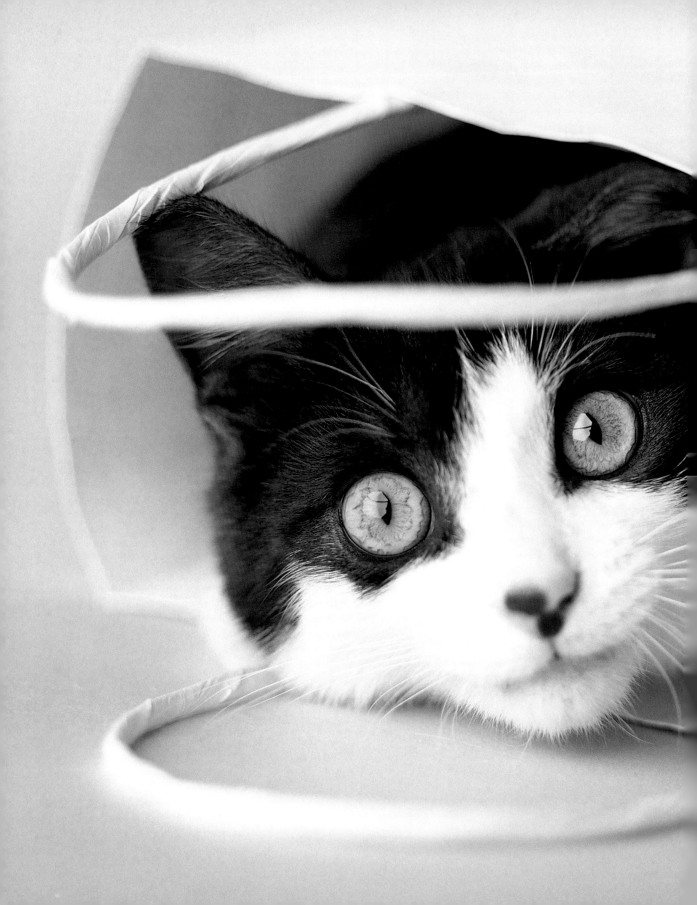

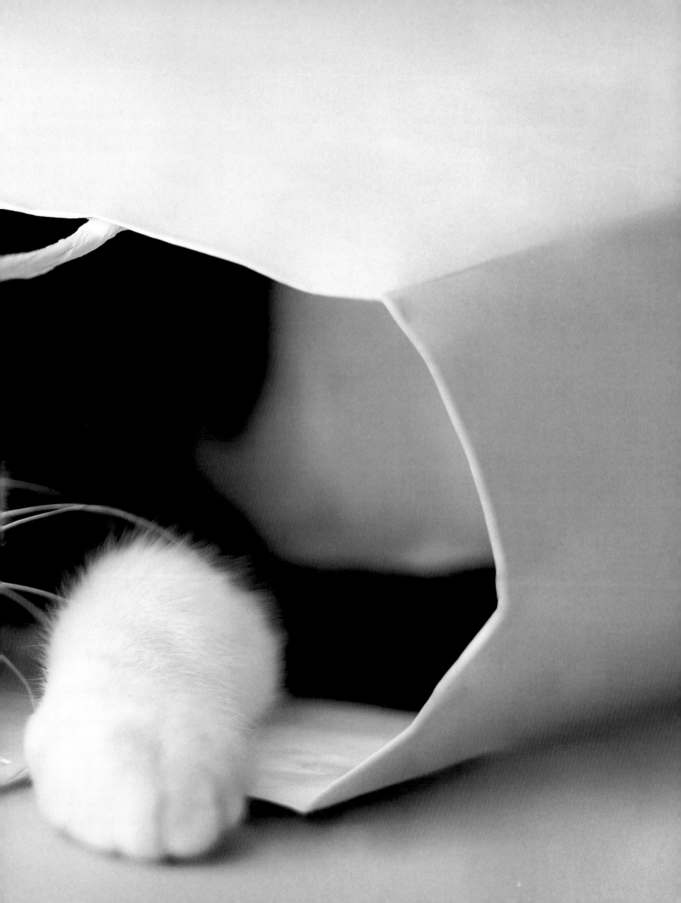

VISITS TO THE VET

Date	Illness	Treatment

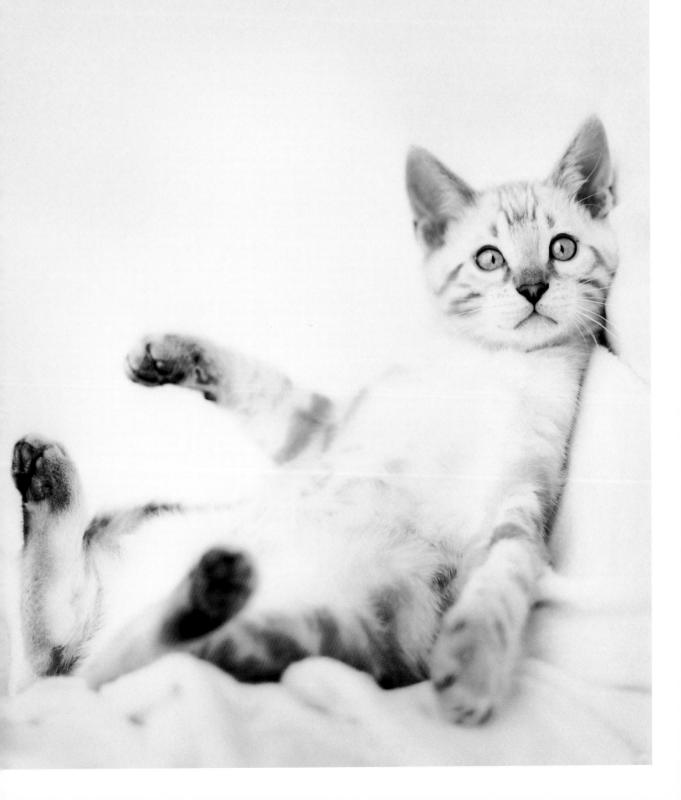

WORMING

Date _____ Date _____ Date _____ Date _____

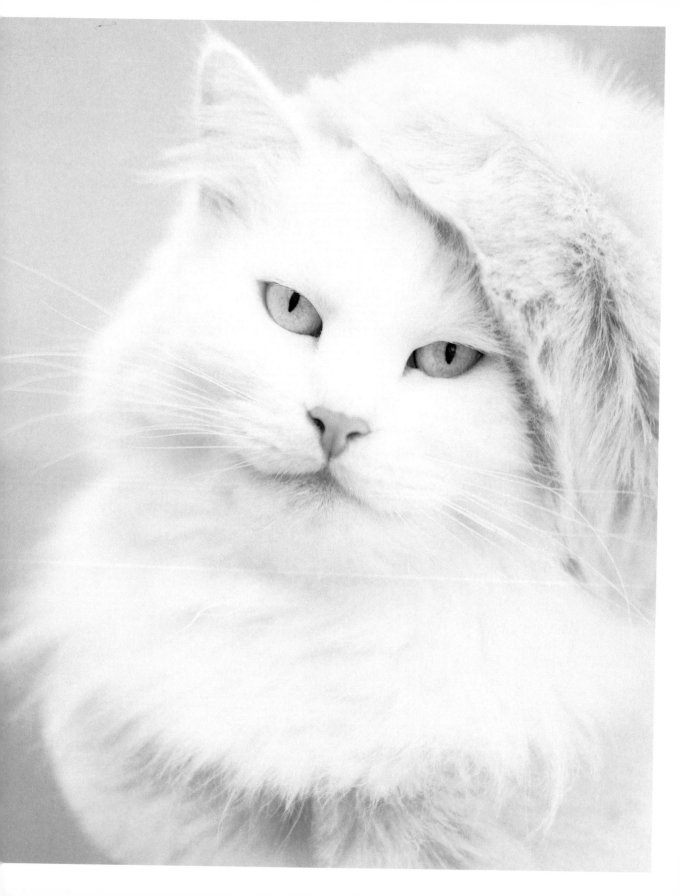

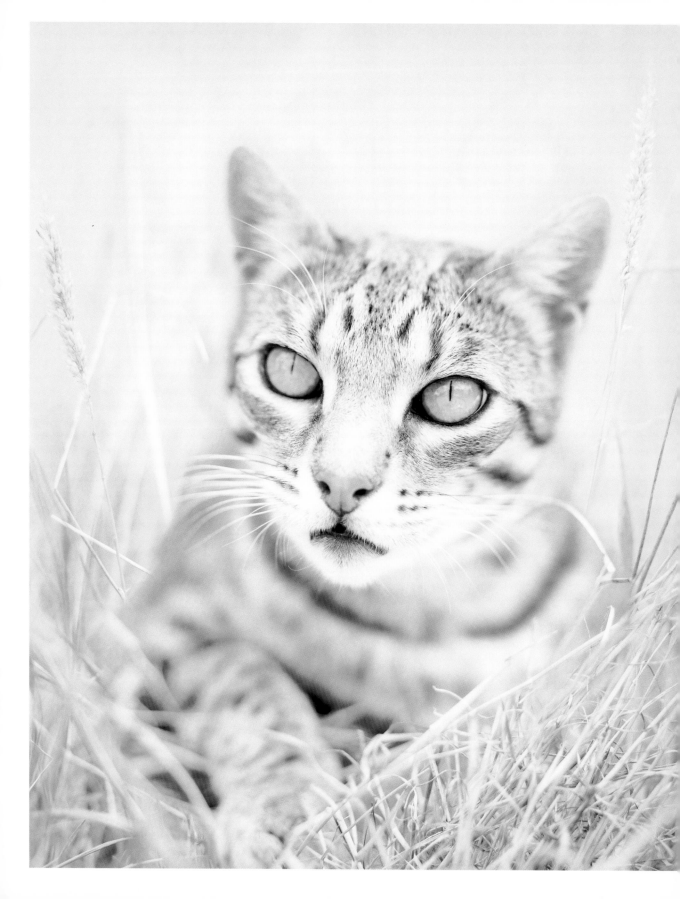

VACCINATION

Date	Vaccine	Date	Vaccine

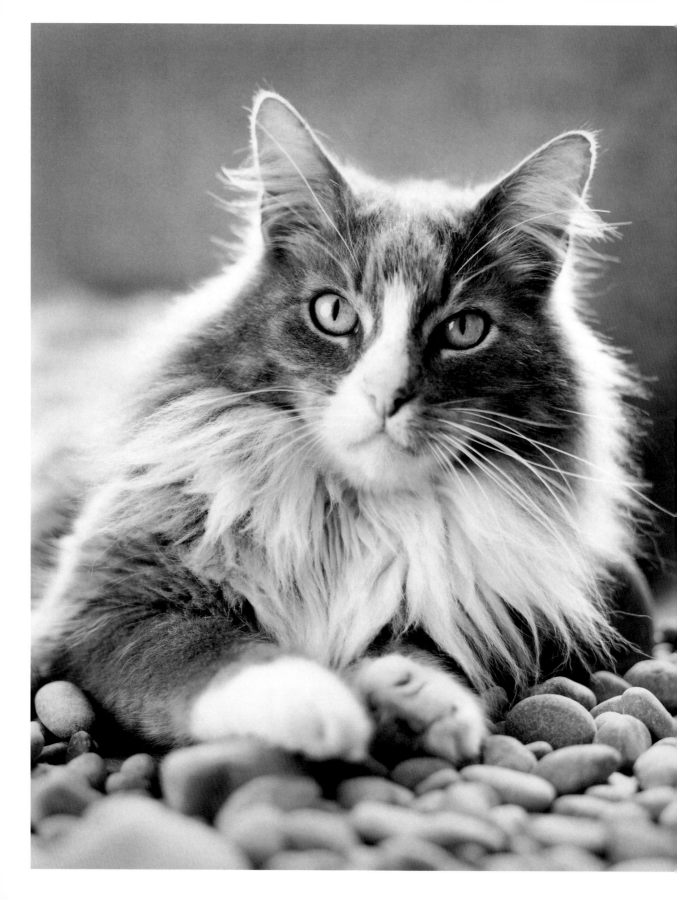

IMPORTANT ADDRESSES

Name

Address

Phone

Name

Address

Phone

Name

Address

Phone

Name

Address

Phone

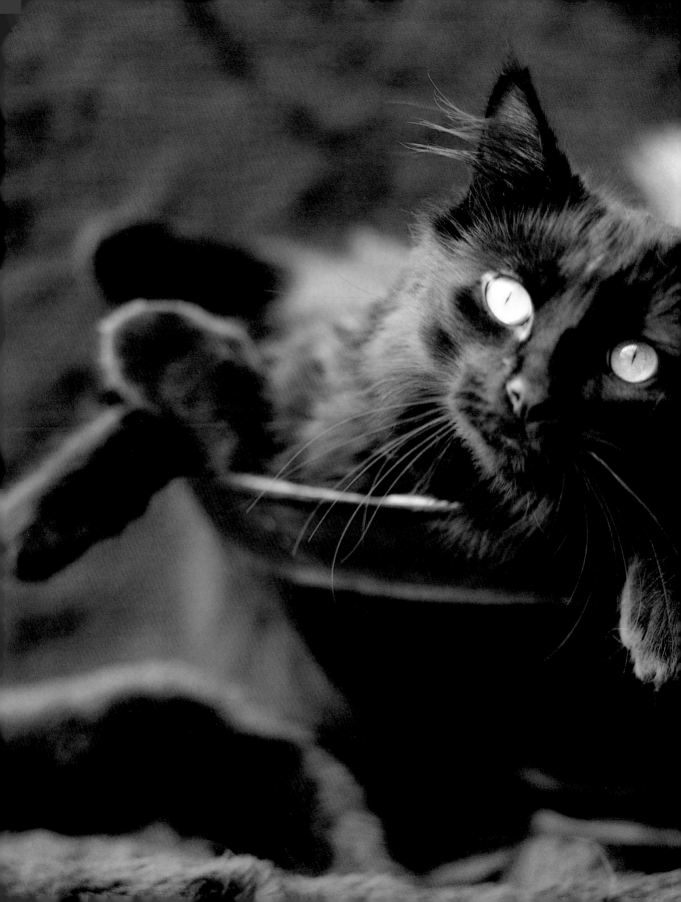

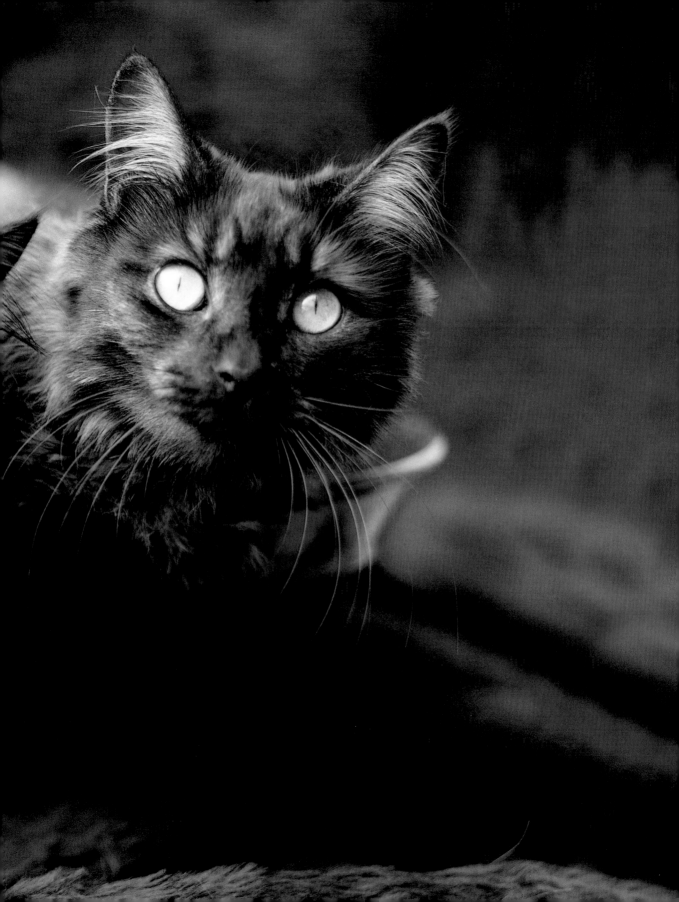

Michael Clarke

Bulfinch Press

Time Warner Book Group
1271 Avenue of the Americas, New York, NY 10020
Visit our Web site at www.bulfinchpress.com

First North American Edition

Published by arrangement with PQ Publishers Limited

ISBN 0-8212-5697-1
Library of Congress Control Number 2004113256

Designed by Kylie Nicholls

PRINTED IN CHINA

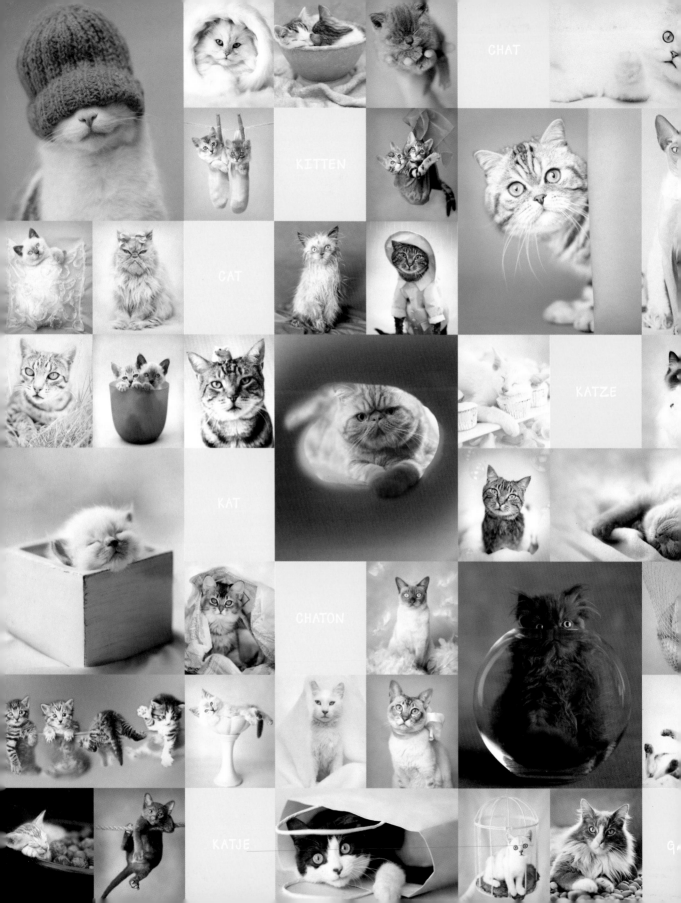

CHAT

KITTEN

CAT

KATZE

KAT

CHATON

KATJE